Bold Truths

—

20 Philosophical Prints

The School of Life

Published in 2021 by The School of Life
First published in the USA in 2022
70 Marchmont Street, London WC1N 1AB

Typeset by Marcia Mihotich
Print designs by Bethany Baker, Calvin Hayes, Jack Smyth,
Marcia Mihotich, Miriam Goldstein, Sarah Easter and Sarah King
Printed in China by Leo Paper Group

A proportion of this book has appeared online at
www.theschooloflife.com/thebookoflife

The School of Life is a resource for helping us understand ourselves, for
improving our relationships, our careers and our social lives – as well as
for helping us find calm and get more out of our leisure hours. We do this
through creating films, workshops, books, apps and gifts.

www.theschooloflife.com

ISBN 978-1-912891-56-6

10 9 8 7 6 5 4 3 2 1

FSC
www.fsc.org

MIX
Paper from
responsible sources
FSC® C020056

GOOD
ENOUGH

GOOD ENOUGH The alternative to perfection is not failure; it is making our peace with the idea that each of us is 'good enough': good enough parents, siblings, workers and humans. A relationship may be 'good enough' even if, at times, there's little sex, a lot of arguments and periods of loneliness and non-communication. A 'good enough' job may be very boring at points and won't earn us a fortune, but we may make some real friends and finish many days tired but with a sense of true accomplishment.

We should step back more often to acknowledge in a non-starry-eyed but very real way that our lives are 'good enough', and that this is a very grand achievement in itself.

Design: Calvin Hayes

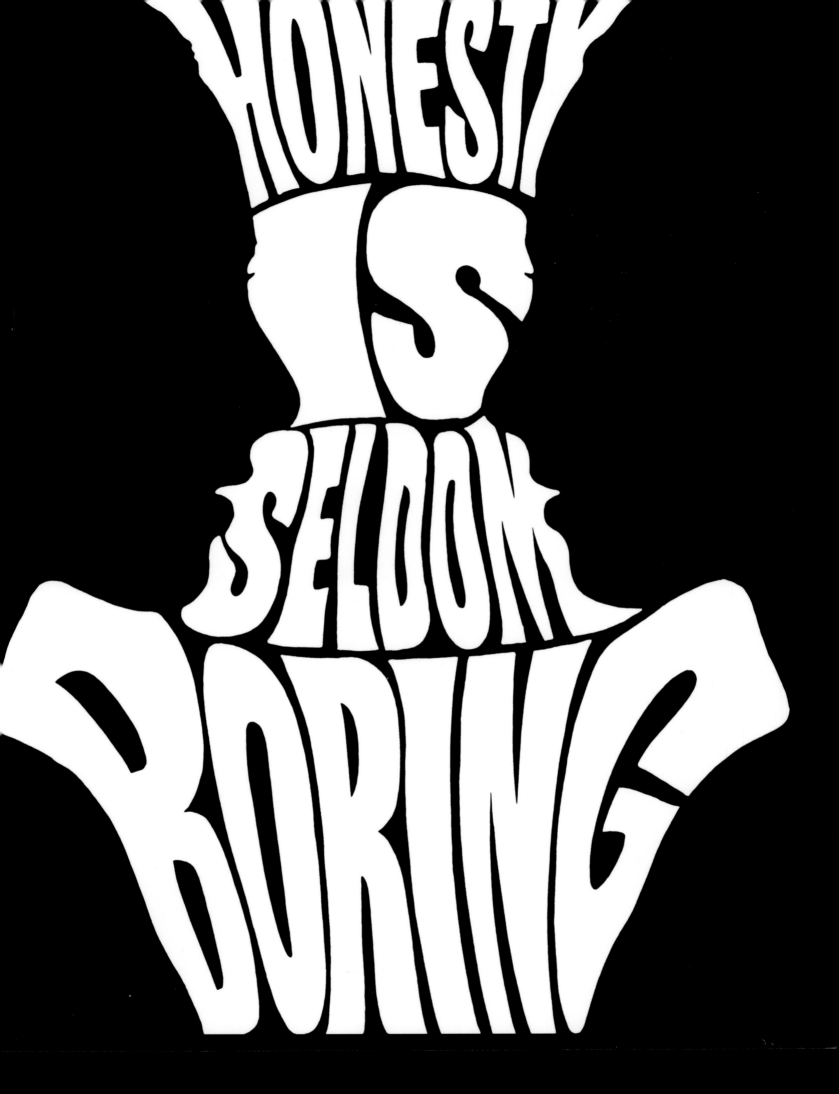

HONESTY IS SELDOM BORING Many of us are reluctant to talk about ourselves for fear of boring other people. We labour under the impression that our lives are nothing special and that there is little about our experience that would hold the interest of the average listener. But the truth is seldom boring, only the sanitised version we most often present to the world. If we are prepared to admit to the trickier sides of our personality, we would find that others are compelled by our candour. We could admit that our sex lives aren't all we had hoped for; that we sometimes feel that we're failing our children; that we long for a life that lies outside what is ordinarily considered acceptable.

Design: Sarah King

THE SCHOOL OF LIFE

EMBRACE THE ORDINARY 'Ordinary' is not a name for failure. Understood more carefully, and seen with a more generous and perceptive eye, it contains the best of life. An 'ordinary' life is heroic in its own way. There is immense skill and true nobility involved in bringing up a child; maintaining a relationship with a partner over many years; keeping a home in reasonable order; getting an early night; doing a not very exciting or well-paid job responsibly and cheerfully; listening properly to another person and, in general, not succumbing to madness or rage at the paradox and compromises involved in being alive.

Design: Jack Smyth

NO ONE IS

NORMAL

NO ONE IS NORMAL Our culture has tried to project an idea of an organised, poised and polished self as the standard way most people are. This encourages us to become impatient and disgusted with ourselves when we don't live up to expectations. We want to shout that we need to buck up, get it together and stop being so weak or weird. But instead of expecting ourselves to be normal in the sense of being calm, coherent and rational, and getting ashamed when we're not, it's far better to recognise the omnipresence and sheer normality of madness, waywardness and alarm in every human soul. No one is normal; the only people we can think of as normal are those we don't know very well.

Design: Jack Smyth

Under-sharing is the greater risk.

UNDER-SHARING IS THE GREATER RISK Over-sharing is often seen as hazardous to friendship. In this view, to be unusually open and frank about our lives is to risk alienating our confidants – or, worse, to give them the means of hurting or embarrassing us. But building intimacy always involves a measure of risk. We can only get close by revealing things that would, in the wrong hands, be capable of inflicting appalling humiliation on us. Friendship is the dividend of gratitude that flows from an acknowledgement that one has offered something very valuable to someone the key to one's self-esteem and dignity. The real risk lies in never making this offer, preventing us from getting truly close to those we would call our friends

Design: Sarah Easter

Insomnia:

Revenge for thoughts you refused to have in the day

THE SCHOOL OF LIFE

INSOMNIA: REVENGE FOR THOUGHTS YOU REFUSED TO HAVE IN THE DAY Feelings and desires that haven't been examined tend not to leave us alone. They linger and spread their energy randomly to neighbouring issues. Unexamined ambition registers as anxiety; envy comes out as bitterness; anger turns into rage; sadness into depression. Disavowed material buckles and strains the system. What most often keeps us up at night are insistent feelings that we haven't found a way to address. Insomnia is in large part revenge for thoughts we have refused to have in the day. In order to be able to find rest, we need to carve out chunks of time where we have nothing to do other than lie in bed with a notepad and pen in order to think.

Design: Calvin Hayes

Fools never worry they might be fools.

THE
SCHOOL
OF LIFE

FOOLS NEVER WORRY THEY MIGHT BE FOOLS The truly
foolish are those who never think of themselves as
such. They carry a skewed picture of how dignified
a normal person can be. They trust that it is an
option to lead a good life without regularly making
a complete idiot of themselves. The truly wise, on
the other hand, have made peace with their own
inevitable ridiculousness. They know that they are
idiots now, have been idiots in the past, and will be
idiots again in the future – and that is okay: there
aren't any other options for human beings. The
road to wisdom begins with a ritual of telling onesel
solemnly every morning, before heading out for the
day, that one is a muttonhead, a cretin, a dumbbell
and an imbecile.

Design: Sarah Easter

Pessimism
isn't
always

Optimism
doesn't
have to be

shallow.

deep.

PESSIMISM ISN'T ALWAYS DEEP; OPTIMISM DOESN'T HAVE TO BE SHALLOW We are right to be suspicious of optimism. Given the manifest suffering that exists in the world, invocations to 'look on the bright side' can seem at best naive and at worst wilfully blind. That is not to say that pessimism is the wiser perspective; a view of humanity as inherently selfish, malign and contemptible can be just as unthinking. A brand of optimism that embraces all that is difficult and troubling about the human condition, and that seeks to highlight the glimmers of hope and goodness that exist within the darkness, is far wiser than shallow cynicism.

Design: Calvin Hayes